The Campus History Series

ILLINOIS STATE UNIVERSITY

On the Front Cover: A 1959 campus welcome sign is pictured with North Hall to the left and Schroeder Hall in the background. (Courtesy of the Dr. JoAnn Rayfield Archives at Illinois State University.)

Cover Background: Old Main is seen around the 1930s. (Courtesy of the Dr. JoAnn Rayfield Archives at Illinois State University.)

The Campus History Series

ILLINOIS STATE UNIVERSITY

April Karlene Anderson
on behalf of the Board of Trustees
of Illinois State University

ARCADIA
PUBLISHING

Copyright © 2017 by April Karlene Anderson on behalf of the Board of Trustees of Illinois State University
ISBN 978-1-4671-2748-6

Published by Arcadia Publishing
Charleston, South Carolina

Printed in the United States of America

Library of Congress Control Number: 2017953085

For all general information, please contact Arcadia Publishing:
Telephone 843-853-2070
Fax 843-853-0044
E-mail sales@arcadiapublishing.com
For customer service and orders:
Toll-Free 1-888-313-2665

Visit us on the Internet at www.arcadiapublishing.com

This book is dedicated to my nieces, Jocelyn and Eleanor, who will one day be a formidable pair of history makers.

Contents

Acknowledgments		6
Introduction		7
1.	The Foundation	9
2.	The War Years	25
3.	Modernizing Campus	71
4.	A New Normal	105
Bibliography		126
Index		127

ACKNOWLEDGMENTS

I'd like to first thank Nelson Smith and his daughters. Without his collection of university photographs and his family's continued support of the Dr. JoAnn Rayfield Archives, I would not have been able to put this book together. Nelson passed away in 1998, but his legacy lives on in his thousands of photographs, many of which are featured here.

I'd also like to thank Ross Griffiths and Dallas Long for their tireless efforts in helping to get this project off the ground and for being so supportive throughout this process. They helped navigate contracts, answered administrative questions, and helped me when this and several other projects were looming. Hopefully, a thank-you here will begin to scratch the surface of showing how much I appreciate them as colleagues and as friends.

My staff of archivists and students have also been of invaluable help during this project. Jenna Self, Julie Neville, Sarah Coffman, and Samantha Wolter have all helped in scanning photographs and checking content. Michelle Woody and Tammy Hansen were also gracious enough to read the draft copy and I cannot thank them enough.

Lastly, I would like to thank the Redbird community. All past, present, and even future Redbirds: your love for Illinois State University makes my job of collecting and preserving your history one of the best on campus. To see your eyes light up when you hold your first president's Civil War swords, to help alumni identify classmates in the yearbooks, or simply to chat with you about your favorite parts of ISU history is what makes being your archivist so much fun and so rewarding. Keep making history, because there is so much more to write.

Unless otherwise noted, all images appear courtesy of the Dr. JoAnn Rayfield Archives at Illinois State University.

INTRODUCTION

The buildings on the campus of Illinois State University tell stories. They tell us about the founding of the university and the many celebrations, hardships, and transitions of its community. Some tell us how the university was once a school for training teachers, and others show how we have modernized into a liberal arts institution. As the university grows, the buildings on campus are remodeled or removed to create room for new construction that meets the needs of the student body. It is within their walls that we can find the story of Illinois State and learn how it has become not only home for so many Illinois State University Redbirds but also one of the top universities in the country.

Founded in 1857, Illinois State University is the state's first public higher education institution. Known then as Illinois State Normal University (ISNU), its early faculty saw the school as a place where innovative education could take place. The university's founder, Jesse Fell, believed in the power of education and put his financial and political strength behind the placement of the school in North Bloomington. As one of the country's early normal schools—a school that trains teachers—ISNU was at the forefront of emerging educational philosophies, including the development of one of the most popular of the time: Herbartianism. Students in the normal school applied this and other educational philosophies in the model school classroom, which was attended by local children. The university's first building, the Administration Building (later known as Old Main), was the home for normal school and model school academics as well as campus administration. As the school grew out of its first building and into facilities that accommodated its growing list of academics, ISNU always remained true to its mission of providing quality education to all of its students.

World events brought significant challenges and changes to the university. Students marched in front of Old Main, the university's first campus building, as they trained for combat during the Civil War. The university's first librarian, Angeline Vernon Milner, created and stored files in the university library of students serving in World War I. The first women's dormitory, Fell Hall, served as military barracks during World War II. The campus saw change during these conflicts both within the university community who answered the call to arms and the buildings that were constructed to accommodate a campus with changing needs. During the presidency of David Felmley, a manual arts building and a farm were constructed for students who wanted teacher training in hands-on skills. Felmley also constructed the first dedicated laboratory school building (now Moulton Hall) for students of both the model and normal schools. A science building was under construction when he suddenly died, so the university named it in his honor. His successor, Raymond Fairchild, sought Depression-era funds to construct the first library on campus. Fairchild later used several campus buildings as temporary training facilities for the military during World War II. He also turned dormitories into barracks and constructed multiple temporary housing units that would later become known as Cardinal Court. However, it was during Robert Bone's presidency and the influx of returning World War II veterans that the campus saw the largest building boom to date. Several residence halls were constructed, including Atkin-Colby, Hamilton-Whitten, Haynie, Wilkins, and Wright Halls, Hewett and Manchester Halls, and the ambitious, 28-story Watterson Towers. The start of the modern West Campus footprint was set in Bone's era with Tri-Towers and the construction of Horton Field House and Hancock Stadium. Bone also expanded classroom space with the additions of Stevenson Hall and DeGarmo Hall as well as the construction of a dedicated building for University High School.

Along with the campus's expansion came a change in the university's name. On January 1, 1964, the university dropped "Normal" from its name and became known as Illinois State University at Normal. The change was met with mixed reactions. Some in the campus community supported the new name, while others saw it as a departure from the university's roots. The

change was eventually accepted across campus, and on July 1, 1967, when the bill to rename the then governing board of the state universities was put forth to the Illinois legislature, "at Normal" was also quietly dropped.

As the university moved into the second half of the 20th century, expansion of the campus slowed. Funding became difficult to obtain, and further campus expansion projects were put on hold or cancelled. A new university union (Bone Student Center) and a new library (Milner Library)—both scaled back from their original plans—were among some of the last projects until the 1980s. However, by 1984, a new arena was in the works. Dubbed Redbird Arena after the university's longtime mascot, a combination of bond revenues, community fundraising, and a student fee increase paid for the new venue. Redbird Arena opened to the public on January 11, 1989, just a few years after Reggie Redbird was introduced as the university's new mascot. Reggie has since made his nest in the scoreboard above Redbird Arena and proudly attends events to support his Redbird family.

Just like the buildings constructed during Felmley's presidency, recent buildings like the Science Laboratory Building, the Center for Performing Arts, State Farm Hall of Business, and the Alumni Center show the university's commitment to providing state-of-the-art facilities to its students and alumni. As the university continues to expand, it also recognizes its historic roots. The recent Cardinal Court renovations recycled brick, asphalt, and concrete from the old housing complex and used it as a base for the new residences. Hancock Stadium's recent renovations completely remodeled the east side of the field, offering a new view (and new seats) for football fans. The first game was played on September 21, 2013, the 50th anniversary of the first game ever played in Hancock Stadium. In the recent demolitions of Central Campus and Atkin-Colby and Hamilton-Whitten Halls, time capsules have emerged that connect former Redbirds to the current campus community. From the university's first building to current renovations, the history of Illinois State University is cemented in the very walls that have guided generations of Redbirds and the many yet to come.

One

THE FOUNDATION

Illinois State Normal University (ISNU), the first publicly funded university in the state of Illinois, was founded in 1857 as a normal school, the ninth of its kind in the United States. Normal schools were dedicated to the training and education of secondary education teachers. For Illinois, this new university would equip the state with a much-needed supply of teachers who could educate students not only in thriving industrial towns but also in small, rural farming communities. This need for highly skilled teachers played a large part in the development of the university's first building, the Administration Building. Known in later decades as Old Main, the Administration Building was the first of its kind in the state and for normal schools. From university administration to classroom instruction, the massive structure housed the entire campus operation. The design, construction, and use of the building, as well as its lasting memory on campus, would become the anchor around which future campus buildings were constructed.

Just as the university was becoming established, a terrible war broke out that called many of the university's students—and even its president—to arms. The Administration Building went from serving a strictly educational purpose to the site for training the university's military-bound men. After the war, the university became one of the premier institutions offering cutting-edge teacher training in the country. The Administration Building was stretched to the limit, and by the end of the century, additional campus facilities were needed to accommodate the quickly expanding university.

Illinois State Normal University was officially founded on February 18, 1857, when Illinois governor William H. Bissell signed an act "for the establishment and maintenance of a Normal University" and a governing board for the school. The board was tasked with finding a location that "shall not be difficult of access, or detrimental to the welfare and prosperity of said normal university." Four communities, Batavia, Washington, Peoria, and Bloomington, placed bids, with Bloomington ultimately securing the new university.

Jesse W. Fell (1808–1887), a Pennsylvania native and Bloomington, Illinois, lawyer, was the man behind the founding of ISNU. Known for his love of trees, Fell also founded several central Illinois towns and helped launch the newspaper the *Pantagraph*. Fell also had a special and lifelong friendship with Abraham Lincoln. At Fell's request, Lincoln served as the attorney for the Illinois Board of Education and created the bond of sale documents to purchase the land in North Bloomington for ISNU.

A trained lawyer and a seasoned businessman, Fell was also known for his talent in horticulture. Fell's interest in horticulture led to a tree business and his connection to William Saunders. Not to be confused with the Kentucky colonel, Saunders was known for his work designing the landscape at the Soldiers National Cemetery in Gettysburg and as the first president of the National Grange. He was first hired by Jesse Fell to create the landscape design for the Fell estate, known as Greenwood. At Fell's request, the board later hired Saunders as the landscape designer and Horace Cleveland as the landscape architect for the university's campus. By 1867, Fell acquired funding from the board to implement the Saunders design, planting 1,740 trees. Today, Fell's vision for a flourishing outdoor laboratory thrives, and the school has been recognized by the Arbor Day Foundation as a Tree Campus USA institution.

Work on the new university began soon after the passage of the Normal University Act on February 18, 1857. However, the financial panic of 1857 hit and work ceased in December of that year. Materials purchased for the building's construction sat exposed to the elements. Charles Hovey, the school's first president, and the board members used their own money, purchased properties, sold land, and transferred money to eventually fund the construction of the building. Nearly two years later, construction resumed using the same materials that were purchased in 1857.

ILLINOIS

State Normal University.

FIRST COMMENCEMENT,

Bloomington, June 29th, 1860.

Graduation ceremonies for the first graduating class were held in an almost-complete Administration Building on June 29, 1860. Enough of the building was complete by June 1860 for the first graduating class to hold its commencement ceremony. By the summer of 1861, the building was finally complete.

When the university opened in 1857, students took classes in Major's Hall in downtown Bloomington while they waited for the completion of the new Administration Building. The first public university building in the state of Illinois, the new Administration Building would house faculty, classrooms, the model school, and the Illinois Natural History Museum. Once completed in 1860, just in time for the graduation of the university's first class (pictured above), the massive structure could be seen for miles.

The second floor of the new Administration Building housed the normal school. The floor held an auditorium that could seat 300 students and several classrooms that surrounded the auditorium's perimeter. Charles Hovey was especially proud of the fact that students could move from the auditorium to their classrooms in under two minutes.

SECOND STORY

Plan III.

(1) Normal-School room—60 ft. x 66 ft.
(2) Two lecture rooms—51 ft. x 32 ft.
(3) Four classrooms—30 ft. x 24 ft.
(4) Four classrooms—27 ft. x 15 ft.
(5) Stairways

Charles Edward Hovey (1827–1897) was the first president of ISNU. Born in Vermont, Hovey pursued education and law before graduating from Dartmouth in 1852 and moving to Peoria, Illinois. While in Peoria, Hovey served as a school principal and later as the superintendent of schools before he was chosen to lead the new university. Hovey worked tirelessly hiring faculty, enrolling students, and working towards building the campus. Hovey served for four years until 1861 and the start of the Civil War.

Hovey's wife, Harriette, donated her husband's Civil War swords to ISNU at the school's 1913 Founders Day celebrations. First held in 1911 as a way to honor the school's founders, the event became an annual affair in 1913 when it honored the school's first president, Charles Hovey, and his service to ISNU and the country. Hovey's service sword and leather sheath are pictured. (Photograph by the author.)

NORMAL RIFLES.

Charles Hovey knew the war would not end quickly. He watched as his students marched in formation in front of the Administration Building. The students called themselves the Normal Rifles and were preparing to go to battle. Along with Jesse Fell, Hovey traveled to Washington, DC, to meet their friend Pres. Abraham Lincoln. Hovey's plan was to ask Lincoln for a regiment. The regiment would consist of ISNU students who must have already graduated in order to serve. Lincoln agreed, and the 33rd Illinois Volunteer Infantry Regiment, also known as the Teachers Regiment, was formed. Hovey and Fell's visit also coincided with the first major battle of the war, the First Battle of Bull Run. Hovey watched the carnage unfold while Fell helped the injured in the field hospital. Hovey returned to the university, stepped down as president, and formed the 33rd Illinois. Fell, at Lincoln's request, returned to Washington, DC, to serve for a year and a half as a Union army paymaster.

Along with a museum, classrooms, and offices, the new Administration Building also contained several study halls. Two of those halls served as the headquarters to two popular literary societies on campus. Originally founded as the Normal Debating Society, the group split in 1858 into the Philadelphians and the Wrightonians. In a nod to the city that proclaimed brotherly love, those that supported the society's president renamed themselves the Philadelphians. The photograph above shows the Philadelphians' hall, located in the Administration Building.

The dissidents formed the Wrightonian Society, named after Board of Education of Illinois member Simeon Wright. The Wrightonian Society's hall, above, was also located in the Administration Building. Though fierce competitors in yearly debate, writing, and performance contests, the societies often worked together to support the university both financially and academically.

Thanks largely to the university, North Bloomington had come into its own in 1865. Businesses were taking root, four churches were founded, and legislation for the Civil War Orphans Home (later known as the Illinois Soldiers and Sailors Children's School) was passed. Taking its name from the school, the town of Normal was founded in 1865 and incorporated in 1867. The same year of incorporation also saw the opening of the children's home, where students from the new university would eventually teach.

By 1880, the campus had outgrown its main building and was in desperate need of space. In 1891, the state gave the university $23,000 to construct a second building north of the Administration Building. The new structure would serve as the model school, giving its students space to learn and the normal students a place to train. North Hall would later serve as the third home of the university library, after the Administration Building (Old Main) and Cook Hall.

Richard Edwards (1822–1908) was the second president of ISNU. Because of a rapidly expanding student population, Edwards began to campaign for additional buildings. He first advocated in 1865 for a dormitory with a gymnasium, and he later pushed for a standalone gym. He also worked to get funding for a second building dedicated to model school work (North Hall). Edwards left the university in 1876, before either building was constructed.

Edwin Hewett (1821–1905) was hired in 1858 by first president Charles Hovey to teach history and geography. A graduate of Bridgewater (Massachusetts) Normal School, one of the first public normal schools in the United States, Hewett was selected by his peers in 1876 to become the third president of the university. Hewett's tenure was difficult; he faced a national economic downturn while trying to keep the university's enrollment numbers up. In an outreach effort, Hewett included ISNU at the 1876 Philadelphia Exposition to showcase the school's work in pedagogy.

Originally known as the gymnasium, Cook Hall was first proposed by Pres. Richard Edwards to state legislators to be a dormitory with an attached gym. Despite his efforts, and those of his successor Pres. Edwin Hewett, the construction of the gymnasium was not approved until 1895. At the request of Gov. John P. Altgeld, the design of the building was altered to look more like a stone castle, an architectural aesthetic he instituted at four other state campuses during his term.

Women were given an exercise hall and a changing room in the new gymnasium. Before the new gymnasium's construction, men and women held gymnastic exercises on the third floor of the Administration Building. Because of the use of poor construction materials, the building showed strain, and exercises were moved to the basement. By 1895, the new gymnasium was constructed with space for both men and women to exercise.

Angeline Vernon Milner (1856–1928) was the first university librarian. Hired by President Hewett in 1890, it was Milner's job to organize and catalog the small university library and the libraries of the two campus literary societies into one centralized library. Milner was a self-taught librarian, studying on her own when she worked at the Illinois State Library of Natural History. During her tenure, Milner managed thousands of books and oversaw the transfer of the library from the Administration Building (Old Main) to Cook Hall and eventually North Hall.

Known to many as "Aunt Ange," Milner would save journals and books for faculty members who might find the topics useful in their work. Milner was also known for being helpful to students looking for research sources and would help them until the paper's completion. As former student Charles William Perry recalled in his article about Milner in the *Alumni Quarterly of ISNU*, she was also known for not having "patience or sympathy for the student who comes to her for help at the eleventh hour." In this photograph, Milner can be seen working at her desk.

Charles DeGarmo (1849–1943), an 1873 ISNU alum and faculty member, brought a popular form of educational theory called Herbartianism from Germany to the United States and the university. Herbartianism at its core has one defining principle: the development of a good, moral character in young children through rigorous education. DeGarmo, along with four other ISNU faculty (Frank McMurry, Charles McMurry, Lida McMurry, and Cecil Van Liew) became known as the American Herbartianists. The pedagogy quickly became popular and brought ISNU national attention as a leader in teacher training.

From the start, ISNU provided real-world classroom experience for its students. Along with the normal school, the university started a model school with students enrolled from the local community. The model school was divided into two departments: grammar and high school. The departments were considered to be laboratories for education. The lab schools continue to operate on campus today, now known as the Thomas Metcalf School and University High School.

21

John Cook (1844–1922), fourth president of the university, was both an alumnus of the school and a faculty member. After graduating from ISNU, Cook stayed at the university, teaching history, geography, reading, and mathematics. Cook's presidency saw the construction of the new gymnasium and North Hall, the first two academic buildings constructed after the Administration Building. Cook left the university in 1899 to become the first president of Northern Illinois State Normal School (now Northern Illinois University), where he remained until his retirement in 1919.

In 1899, Arnold Tompkins (1848–1905) became the fifth president at ISNU and is one of two presidents in the university's history to serve less than a year. Replacing John Cook, Tompkins brought with him a love of teaching and quickly became popular among the students and faculty for his lectures. Ten months after he became president, Tompkins was offered the chance to become the first president of the Chicago Normal School (now Chicago State University), which he accepted.

The Administration Building was known for its distinctive bell tower, a structure that on clear days could be seen for miles. The bell was a familiar sound to campus students; it signaled the end of classes and rang for special events. The bell currently located on the Quad is often thought to be the original bell to the Administration Building. In fact, it is the second bell, replacing the first bell, which shattered in 1880.

THE VIDETTE.

VOL. I. NORMAL, ILL., FEBRUARY, 1888. No. 1.

The Vidette.

ISSUED MONTHLY DURING THE SCHOOL YEAR
BY THE
Students of the Illinois State Normal University,
NORMAL, ILLINOIS.

M. KATE BIGHAM, . . EDITOR-IN-CHIEF
HANAN McCARREL, . . BUSINESS MANAGER

Subscription, 60 Cts. Per Year. 25 Cts. Per Term. Single Copies 10 Cts

Remittances should be made to the Business Manager. Communications for publication should be directed to the Editor-in-Chief.

Entered at the Postoffice at Normal as second class matter.

∴ EDITORIAL. ∴

To the students of the Normal University, and to those who have gone forth from this school, but who still look back to it with fond remembrance, THE VIDETTE brings greetings.

For several months the question of starting a school paper has been agitating. Members of the higher sections discussed the question in a general way. Finally meetings of Section A were called and committees were appointed to look into the matter, and report as to the benefits to be derived and the risk incurred in embarking in so weighty an enterprise. Several meetings were held, in which the question was thoroughly discussed. Much was said concerning the responsibility of such an undertaking, but all agreed that a school paper as the student's voice, if properly conducted, would be a great advantage.

It was considered best to place the management of the paper in the hands of the school. Rules and regulations were drawn up and presented to the school. After several meetings, in which the students engaged in spirited discussions, these rules were adopted.

In accordance with these rules, a board of managers were chosen. This board consists of the following members: Ida E. Crouch, Florence M. Gaston, Ed. B. Smith, and H. S. Brode; Middle Class, Cora Laign, Nellie R. Parsons, and S. Warren; Juniors, John T. Search and Edna Mettler; High School, Kittie Wright, Josie Roberts, Clarence Carroll, and E. C. Bailey.

The board organized by electing the following officers: H. S. Brode, president; Kittie Wright, secretary; Ida E. Crouch, treasurer. They met and elected an editor, M. Kate Bigham, and business manager, Mr. H. McCarrel.

The financial success of the paper is already insured. That its readers and contributors may derive the desired benefit from it, we ask that it be made what it is purported to be— the student's organ. The columns of THE VIDETTE are open to contributions from any members of the school. We hope to have contributions from the different members of the faculty. We ask former members to write for us. That you may know what has been done the past term, we have, in our news columns, given a synopsis of the work done in the Societies, the changes in the course of study, and throughout the school generally.

RULES AND REGULATIONS
GOVERNING THE PUBLICATION OF THE STUDENTS' PAPER.

1. The students' paper shall be controlled by a Board of Managers elected by the students of the University.
2. The school shall be considered as being made up of four sections, three of these being in the Normal Department and one in the High School Department.

The three Normal sections shall be known as the Senior, Middle, and Junior classes. The meaning of these classes shall be: Seniors, those doing 3d year work; Middle class, those doing 2d year work, Juniors, those doing 1st year work.

In 1887, students held meetings to decide whether they should launch a student-led newspaper. Ultimately, the students united in favor of a newspaper, saying that "all agreed that a school paper as the student's voice, if properly conducted, would be a great advantage." Named the *Vidette*, the first paper was printed in February 1888. Though started as a student paper, the *Vidette* also reported on local activities, club meetings, and events in the town of Normal, serving as both a community and student news source.

Two

THE WAR YEARS

A new century brought hope and prosperity to the country as well as a quickly growing campus population at ISNU. As the number of students increased, so did the need for more classrooms and specialized educational spaces. A gymnasium, a farm, and a training (laboratory) school were all constructed to better serve the university's faculty and students. These spaces, placed around the campus's first building, Old Main, created the academic heart of the campus.

The university's longest serving president, David Felmley, oversaw many of the construction projects that would change the face and academic structure of campus. The new Manual Arts Building (now known as Edwards Hall) would provide a location for the training of practical skills such as sewing, woodworking, metalworking, and bookbinding that had not been previously offered. A new farm moved students out of a basement classroom in Old Main and onto the fields to put practical skills to use. A building dedicated to the laboratory schools (now known as Moulton Hall) was constructed as well as the university's first on-campus dormitory building. However, with that prosperity came heartache as a war once again took students from the campus, and, just as he retired, illness took a beloved president.

Following in the footsteps of his predecessor, Raymond Fairchild continued building the campus during a time of war. The campus became a training ground for battle-bound aviators as students adjusted their living arrangements, moved class schedules, provided support for their military classmates, and adapted to a new way of life. Toward the end of his presidency, Fairchild laid the groundwork for his successor to begin a new age of hope and prosperity for the university.

In contrast to Arnold Tompkins's short presidency, his successor, David Felmley, was the university's longest serving president. Appointed in 1900, Felmley helmed the university during a time when the campus and the nation experienced significant social change. Felmley believed that all people deserved the right to a high school education and saw normal schools as the place for both education and teacher training. At his core, Felmley was a mathematician and scientist. He was first employed by the university in 1890 as a professor of mathematics.

The new century saw an increase in the need for specialized education. Teachers were needed not just to teach languages and arithmetic but also to teach practical skills for pupils in rural communities and those not advancing to higher education. Felmley saw this need and pressed for funding to construct a building on campus dedicated solely to the teaching of manual arts. Felmley obtained the funds, and the Manual Arts Building was opened in 1909.

Manual arts included handwork (cutting various media for teaching projects, basketry, and crafts), bookbinding, metalworking and woodworking, furniture and cabinetmaking, mechanical drawing, and the theory and practice of teaching manual arts. Along with manual arts, students in the domestic science and home economics programs also took classes in the building.

For decades, Capen Auditorium was the home for campus-wide assemblies. Opened in 1928, Capen Auditorium was the only location on campus that could accommodate all students and faculty in one building. Named for normal school board member Charles L. Capen, the auditorium was often used for visiting lecturers, presidential addresses, student competitions, plays, and concerts and was also used for the funeral of David Felmley. In this early 1920s photograph, President Felmley addresses the student body.

Agriculture classes have always been part of the curriculum of the university. Several courses were taught in the basement of Old Main. In 1911, the university offered a four-year degree course in agriculture and the Department of Agriculture was founded. The university secured 95 acres of land roughly south and west of the current location of University High School. It included several buildings, such as the farmhouse and the barn, which were planned by then department head I.A. Madden.

The new University Farm offered classroom space for students to learn new and emerging agricultural techniques as well as basic machine repair. This undated photograph shows a classroom at the University Farm, where students had access to tools to perform in-class work on various farming equipment.

The farm would not only prepare students for farm science and administration but also allow those students to demonstrate their skills to the local community. In this 1959 photograph, the community was invited to tour the farm and see student demonstrations.

As the student population grew post–World War II, classroom and dormitory space became limited. The land used by the University Farm was needed for the campus. The University Farm moved a few miles north of campus in 1962 to a larger location on Gregory Street and again in 2002 to its current location 15 miles north in Lexington, Illinois. Only one building remains from the original farm—the Vitro Center, where art students currently learn about glassblowing.

Another Felmley-era building, the Thomas Metcalf Training School, was a welcome relief to the crowded training school (North Hall). Named for the first school supervisor, Dr. Thomas Metcalf, the school housed a kindergarten, elementary school, and high school. In 1947, the elementary and high school departments split. In 1957, the elementary school and kindergarten were moved to a new building, which was also named Metcalf. The high school remained in the old Metcalf building and was named University High School.

For decades, students at University High School took classes on the same campus as many of their teachers. But the building was starting to show wear, and a new high school was constructed in 1966. The building was once again repurposed, this time for a mix of administrative and academic needs. The Office of the Registrar, Veterans Services, and the Department of Physics were moved into the old building, which was renamed Moulton Hall in honor of Samuel Moulton, member of the first Illinois Board of Education.

In 1918, the first student dormitory on campus opened its doors. Prior to the dormitory, students boarded with locals in the town of Normal. Residents, sometimes the very professors with whom they were studying, would rent out rooms in their homes to students. Some students even participated in boarding clubs, where men and women shared daily living duties such as cooking and laundry.

Decades after President Edwards's attempt at opening a campus dormitory, President Felmley secured funding for a women's living facility. Taking into account population increases, the original drawings called for an eventual expansion to the structure. That expansion was completed in 1953. The building was named Fell Hall in honor of the university's founder, Jesse Fell.

Just like modern students, residents shared rooms in Fell Hall. Rooms included two beds and desks for each resident to work. Unlike their boarding counterparts, students lived on campus and no longer had to walk from neighborhoods in the town of Normal—many areas of which had unpaved roads—to the campus. Room and board for one resident at Fell Hall was $6.50 a week.

Fell Hall also included social spaces, such as a dining room where residents ate their meals. In 1943, after lunch service, a fire broke out and destroyed the attic and roof of the building. At the time, the hall was the temporary living quarters for trainees in the V-12 naval training unit. Men in the unit were moved to McCormick Gym and lived there until repairs to Fell Hall could be made.

Common rooms in Fell Hall were utilized in a variety of ways. Meetings for small groups could be held on the main floor, or the common rooms could be used as quiet study spaces. Just like in this drawing room, various spaces could also be transformed for larger residential meetings or for annual dances.

A large kitchen was needed to feed the many residents living in Fell Hall at a given time. While boarders typically shared the duties of meal preparation, Fell Hall residents could rely on the hall's staff to provide their meals. However, residents had to be sure to be in the dining area on time or risk missing a meal.

When the First World War started in 1917, the campus saw many of its students leave to fight. Students and faculty, both men and women, enlisted and volunteered their services at home and overseas. The university's first librarian, Angeline Milner, served on a university-wide committee helping students and alumni serving abroad. Milner created a comprehensive collection of informational files on all ISNU students, faculty, and alumni serving in the war. This image of David Lutz is one of the thousands of pieces collected by Milner during the war.

Milner also created surveys that she sent out to students and alumni whom she identified as service members or volunteers. The surveys included information about their hometowns, when they attended ISNU, where they were deployed, what battles they participated in, what injuries they sustained, and what honors they received. Many of the survey respondents replied with letters to Milner describing their experiences and asking for news of home. Milner always replied and kept up correspondence with many alumni and faculty long after the war was over.

> My Dear Miss Milner:—
> It never occurred to me when I wrote you the last letter that my next one to you would be written from an army cantonment. But owing to the exigencies of fate, I am doing so, and what seems strange to me is that I find pleasure in doing so.
> I really believe the one single thing that prompted me to the act of enlisting was the publication in the Pantagraph of the 'Roll of Honor' of I.S.N.U. When I read the names of all those who had gone, I proved to myself that since the

★ ★ ★ ★ ★

O silently and secretly moving throng,
In your fifty thousand strong,
Coming at dusk when the
 wreaths have dropt,
And streets are empty, and
 music stopt,
Silently coming to hearts that wait
Dumb in the door and dumb
 at the gate,
And hear your step and
 fly to your call—
Every one of you won the war,
But you, you Dead,
 most of all!

★ ★ ★ ★ ★

11

The 1919 yearbook, the *Index*, honored the men and women who fought and volunteered during the First World War. Ten students were listed in the Gold Stars honor roll, which detailed their school attendance, their military service, and their manner of death.

Women were also an integral part of the war effort. Many served in volunteer capacities with the YMCA and the Red Cross. Some were called to service as nurses in the Army Nurse Corps, where they tended to the wounded overseas. ISNU alumna Ada Adcock was part of the Army Nurse Corps for just over a year, serving overseas in France for approximately eight months.

Ada Adcock was one of the many students who responded to Angeline Milner's survey requesting information about her service. On this page, Adcock lists Stockton, California, as her residence, attending ISNU for about two years, and four locations where she served during the war.

Ellen Babbitt was another of Angeline Milner's many contacts. Like many former students and faculty, Babbitt communicated with Milner her thoughts on and experiences in the war. Here, she writes to Milner from the Hotel Regina in Paris, France, with the hopes that the war will soon be over.

While tribute was paid to the dozens of university men who fought in the First World War, the 1919 yearbook, the *Index*, also recognized the 11 women who volunteered for various service organizations and the Army Nurse Corps.

David Felmley Hall of Science

During his tenure, President Felmley oversaw extensive physical growth to the campus. Five buildings were constructed, including the Manual Arts Building (now Edwards Hall), the Thomas Metcalf Training School (now Moulton Hall), Fell Hall, McCormick Gymnasium, and the Felmley Hall of Science.

Felmley regularly asked the normal school board for funds to construct a new science building. By 1926, science courses were packed and classrooms were spread out across campus to facilities that were not equipped for science-based lectures. The normal school board finally approved the construction of a new science building at a cost of $275,000, and plans for the building's construction were approved in 1928.

Originally, the gymnasium was named for Felmley, but when he took ill in 1930, plans were changed to name the new science building in his honor. Felmley died on January 24, 1930, just one week after stepping down from the presidency. He was so respected by students and faculty that they stood as honor guard as his body laid in repose and during his funeral in Capen Auditorium.

Opened in 1925 and originally named for President Felmley, McCormick Gym was an answer to an overcrowded campus. After World War I, enrollment rose, and newly minted teachers found themselves competing statewide for available jobs. Felmley sought to relieve the overcrowding on campus by proposing the construction of 11 buildings, of which only a few were approved. The gymnasium, one of the few buildings that were funded, was a modern take on its predecessor, Cook Hall.

Harry Alvin Brown (1879–1949) was the seventh president of the university. Serving from 1930 to 1933, Brown helped keep the university's doors open when it was in danger of losing its accreditation. Brown reorganized the administration of the school, creating departments for the various disciplines taught on campus. Brown's work to keep the university's accreditation could not save him from scandal, and he abruptly resigned in 1933.

After the decision was made to name the new science building after President Felmley, the gymnasium was renamed McCormick Gymnasium. The new name was to honor former history and geography professor and ISNU alumnus Henry McCormick who served the university for 43 years until 1912. As seen in this 1930 photograph, President Brown presided over the rededication ceremony.

While the new gymnasium boasted a number of courts and a swimming pool, students still enjoyed outside activities, like the women in this undated photograph playing basketball on the gymnasium's grounds.

Smith Hall, the first male dormitory for ISNU, was a private residence leased by the university in 1934 and purchased in 1939 by the University Club. The home was previously owned by Col. D.C. Smith, a prominent local resident who had fought in the Civil War.

Though it was never a fraternity, the men who lived at Smith Hall formed a kind of brotherhood that frequently participated in university events and gatherings such as homecoming parades and university-sponsored activities. The house members even held initiation ceremonies for incoming residents.

Smith Hall was large, able to accommodate up to 33 men, and included spacious grounds that took up almost an entire city block. The house was demolished in 1959 to make way for a new dormitory complex, Hamilton-Whitten and Atkin-Colby Halls, which eventually became collectively known as South Campus.

Raymond W. Fairchild (1889–1956) was the eighth president of ISNU and second longest serving president in school history. Fairchild was instrumental in obtaining state and federal funding to either start or renovate 10 buildings on campus. Fairchild's administration brought graduate coursework to ISNU, making it the first teachers college in the state to offer continuous graduate coursework. ISNU was also the first school in the nation to offer special education training in all areas of education.

Originally constructed for home economics training, Rambo House served as a laboratory, a dormitory, and an alumni service area before it was retired in 2005 and demolished in 2016. Utilities were split in the house, giving students a chance to put in to practice the skills they were learning for both gas- and electric-enabled classrooms and homes. While one side of the main floor had gas and the other electric, both sides had a living room, a dining room, and a kitchen.

This c. 1938 document lists the needs for a new home management house for the students of the home economics training program. The house not only needed to comply with the requirements of the Smith-Hughes National Vocational Education Act of 1917 but also needed to accommodate a rapid increase in the number of students enrolled in the program.

Women were required to live in the dormitory-style quarters on the top floor of Rambo House for nine weeks. In some cases, women were allowed to bring their children to live with them in the dorm. Named for Jesse Rambo, first head of home economics, Rambo House offered a place for the campus to host dinners and events while allowing home economics students the chance to use their new skills in real-world scenarios.

A list of equipment needed in the home management house was created with associated costs. Items included assorted linens for various dining functions, towels, sheets, glassware, and silverware. Thirty blankets that were "at least 80% wool" were priced at $4.05 a piece for a total cost of $121.50.

Angeline Vernon Milner, the university's first librarian, oversaw the library's collection for 37 years until her retirement in October 1927. Milner died only a few months later, on January 13, 1928. Primarily made up of the university's collected textbooks and of the libraries from the Wrightonian and Philadelphian Literary Societies, the entire collection was moved three times during Milner's tenure. The library first lived in Old Main, moved to Cook Hall upon its completion in 1898, and later moved to North Hall in 1913.

Eleanor Weir Welch (1892–1987) was the university's second head librarian. Welch's training as a librarian happened at a time when the profession was undergoing a transformation from administratively task-driven to theory-based and academically influenced. Welch brought innovation to the campus, including developing a dedicated library for the laboratory school, adding 20,000 books to the collection in four years, and implementing a book buying policy based on collection maintenance rather than on demand.

Welch was also responsible for the design of the university's first dedicated library building, originally called Milner Library (now known as Williams Hall). Welch wrote extensively on what the new library needed in order to be successful. She points to "pleasing surrounding, good light, and a quiet atmosphere" as important and that without "beauty and quiet," students will not be attracted to the library. Welch even uses research on noise and its effects on "concentrated reading."

> INTRODUCTION
>
> No matter how well planned or how well furnished the library, how well chosen the book collection, or how efficient the librarian, unless the library has beauty and quiet it will not of itself attract students. Pleasing surroundings, good light, and a quiet atmosphere are essential to the use and enjoyment of books. So in planning new school-library quarters or remodeling old ones a knowledge of the need for and principles of soundproofing, of adequate lighting, and of the use of color is necessary. The engineering is for the technically trained, but the ends to be achieved are for the librarian to decide.
>
> SOUND CONTROL
>
> Recent research shows that these have much to do with pupil health. A few years ago Dr. D. A. Laird came to the conclusion that noise lowered efficiency 15 to 20 per cent. Sudden noises, or continuous noise (though the hearer might be unaware of it) caused, first an increased tension of all voluntary muscles; second, a lessening of the activity of the digestive tract; third, increased pulse rate; fourth, increased blood pressure, and last, a consumption of more bodily calories to accomplish results. The result is the pupils lowered ability for concentrated reading, bad study habits, and behavior difficulties.
>
> The library must be planned to avoid three types of noise, two of which are beyond the librarians control.
>
> Outside Noise. The library should be located away from the noises of playground and busy streets. Playground and athletic field noises are the most disturbing for they are more appealing and meaningful to the pupil. The sound of busses, of trucks, and cars convey little meaning, but they produce a steady hum and grind that unconsciously wears on the nerves.

Started in 1938, the first Milner Library was opened in 1940 and quickly became the academic heart of the campus. The building was also one of several buildings on campus that were constructed or renovated using federal funds from the Public Works Administration, one of Pres. Franklin Roosevelt's New Deal programs.

The main hall served as a study area for students. As per Welch's instructions for the design of the space, the study hall was spacious, provided a lot of natural light, and was beautifully decorated. The original blueprints for the building included window dressing designs and plans for study tables and desks.

The library was also an academic hub, serving hundreds of students at a time during peak study hours and testing days. Students were expected to be respectful of one another when studying in the main hall.

Some study areas in the library were smaller, providing students with enclosed study rooms or quiet reading spaces. As per Welch's instructions, all study spaces in the library were to be pleasant yet quiet so that the students could work with little interruption.

By 1941, the world was once again thrust into war. As before, the university watched its enrollment drop once the United States entered World War II. This war was different; college-age men who would have gotten an education first overwhelmingly elected to join the military. Colleges and universities across the country saw their enrollment decline, and many wondered if they would be able to stay open. This service flag shows the number of ISNU students who were serving or had been killed in war.

In an effort to rapidly bolster their number of commissioned officers, the US Army and Navy began a series of federally funded programs to train new officers on college and university campuses across the country. While the Army primarily trained its soldiers in specialized technical skills, the Navy focused on training officers while they received a full college education. This 1944 ISNU Homecoming football program cover reflects the period and honors the students who were fighting in the war.

50

At ISNU, sailors enrolled in the early V-1, V-5, and V-7 programs, which began in 1943. These programs would eventually be absorbed into the larger V-12 program. In this page from the 1943 V-12 catalog, students in the program learned aviation, both how the aircraft worked and basic flying skills. Courses included Vibration and Dynamic Balance and Mechanism and Machine Design.

NAVY V-12 CURRICULA AND COURSE DESCRIPTIONS

AE12. Elementary Vibration and Flutter. Two lecture-recitation periods per week.

Prerequisites: Differential Equations (M7), and Aerodynamics II (AE2).

Study of fundamental equations of motion, Lagrangian equations; theory of static and dynamic balance; elementary theory of flutter, Kassner and Fingado charts. Theodorsen's theory.

AE13. Vibration and Dynamic Balance. Two lecture-recitation periods per week.

Prerequisite: Differential Equations (M7).

Kinematics of vibration; vibrating systems; multi-cylinder engines, dynamics of crank mechanism, natural frequencies of torsional vibrations, torque analysis, vibration dampers.

AE14. Airplane Static Test. One lecture-recitation period and one laboratory period per week.

Prerequisite: Airplane Structures I (AE4).

Proof and ultimate static test of airplane control system and control services. Test of structural elements such as sheet stringer panels, tension field beams, etc., including use of Huggenberger, Tuckerman, and wire strain gages and various methods of obtaining deflections. Jig drop test of a shock strut or rotational drop test of an airplane including interpretations of a space-time record. Preparation of static test reports.

AE15. Mechanism and Machine Design. Two lecture-recitation periods and two laboratory periods per week.

Prerequisite: Kinematics (ME1).

Design of machine components with respect to static and dynamic forces, critical speeds, and material properties. Study of cams, linkages, gear trains, clutches, and mechanisms, with particular reference to aircraft engine practice.

AE16. Aircraft Power Plants. Three lecture-recitation periods per week.

Prerequisite: Preceded or accompanied by Heat Power II (ME11).

A descriptive course covering construction and operating characteristics of aircraft engines and accessories. Description of

U.S. NAVY V-12 presents BELL BOTTOM BALL

FELL BARRACKS
9 FEBRUARY 1945
2100

The campus saw itself as an important part of the war effort both in training and supporting the sailors on campus. University activities and events were often dedicated to the nation's soldiers and sailors and the V-12 program. This cover from the 1945 Bell Bottom Ball shows one of the many events held on campus sponsored by or for the Navy V-12 unit. This event was held in Fell Hall (Fell Barracks at the time), where some of the Navy V-12 students were housed.

SIXTH GRADUATION CLASS
UNITED STATES NAVY V12 UNIT COMPANIES
JUNE 1945
ILLINOIS STATE NORMAL UNIVERSITY

The high demand for courses, and thus teachers, for both students and sailors helped the campus dramatically expand its academic offerings during this period. However, once the war was over, the Navy no longer needed the V-12 programs. In 1945, the last ISNU V-12 class took its photograph in front of Old Main. The program officially ended, and the facilities used by the program, including Smith Hall, Fell Hall, and the University Farm, were converted back to civilian use.

With the end of the war and the rise in use of the GI Bill, the university saw an increase in veteran students. Many of these veterans had families and needed accommodations beyond what was considered traditional student housing. In 1946, with money from the federal Public Housing Authority, the university created a housing complex using temporary barrack-style trailers.

The housing complex was located at the south end of the University Farm. Families moved in the following year and took advantage of the space around them. They created gardens and playgrounds and eventually started a kindergarten for the children living in the complex.

They adopted the name Cardinal Court as a nod to the university's mascot and school color. It took 13 years for a permanent complex to be constructed and for the original Cardinal Court buildings to be demolished in 1962.

Campus administration had outgrown its walls in Old Main. As the student population soared after World War II, President Fairchild saw the need for a variety of campus offices, classrooms, and dormitories. Offices for campus administration were no exception.

Known simply as the Administration Building, the new home for administration opened in 1950. To honor the first president of the university, the Administration Building was renamed Hovey Hall in 1959. The four-story structure was simple in its design but featured exterior aesthetics similar to other buildings on campus.

Almost 20 years after it first opened, Hovey Hall was in need of additional administrative space. Doubling the original building, the East Wing was added in 1967 at a cost of $1 million.

Hovey Hall included offices for typing and mimeography. With the increase in the student population came the increase in the number of forms, pamphlets, leaflets, and other paper files created for the daily operations of campus life. Offices and staff workers were needed in the Administration Building to carry out this work.

After World War II, the university was in desperate need of permanent housing. Fewer residents were taking boarders, and the handful of dedicated dormitory space on campus was full. By 1950, plans were approved to construct a dual dormitory that could hold both men and women.

The new dorms were to hold up to 156 residents each and be an easy walk to campus. Dunn Hall was on the southeast corner of University Street and Hale Street, while Barton was directly north, on the northeast corner of University Street and Dry Grove Street. Both Dunn and Barton would later hold up to 213 residents each.

The Dining Center for Dunn and Barton Halls was directly between the two dormitories, connecting them together. When the residences first opened, room fees were $4 a week, while boarding (including meals) was $11 a week.

The women's dorm, Barton Hall, was named for the first and longtime women's dean, O. Lillian Barton. In this photograph, two students pose for university photographer Nelson Smith to show how the living quarters could be shared.

The men's dorm, Dunn Hall, was named for Richard Dunn, a lawyer, board member, and ISNU alumnus who created the self-liquidating plan that financed the new dormitories. Also posing for university photographer Nelson Smith, these Dunn Hall men visit with each other in one of the dormitory's rooms.

Residents at Dunn and Barton Halls changed through the years. In the early 1960s, both became men's only dormitories. However, by the late 1960s, Dunn and Barton Halls both became women's only dormitories holding up to 213 residents each.

Even after the construction of the new 156-bed Dunn and Barton Halls, the university was still faced with a bed shortage. In 1954, plans were approved to build a third women's residence adjacent to the new Dunn and Barton dormitories.

A sign was placed on the corner of Main Street and Dry Grove Street during Walker Hall's construction declaring "No state tax funds used in this project" and "Financed by $1,650,000 revenue bond issue."

Located directly west of Dunn and Barton Halls, Walker Hall bordered all of Main Street between Hale Street and Dry Grove Street. The placement of Walker Hall created a miniature quad for the residents of Dunn, Barton, and Walker Halls. The area would later become known as Central Campus.

The 410-bed dormitory was named for Lewis Walker, an ISNU alumnus and former board president. When Walker first opened in 1956, the dormitory housed only freshmen women. Later, only women in upper classes were allowed to board. By 1962, the dormitory only housed men, and by 1983, it had become a coed residence hall.

These Walker Hall residents stay up late as they drink coffee and study for an upcoming exam. This photograph was one of many taken by university photographer Nelson Smith to show how students lived and worked in their dormitory rooms.

Along with the change to coed residency in 1983, Walker Hall also became home to both the International House (I-House) and the Honors House. I-House is one of the oldest such university housing programs in the state. It later moved to Atkin-Colby Halls and currently resides in Manchester Hall.

Another of President Fairchild's construction projects was a new building for the elementary laboratory school. The current lab school (now Moulton Hall) was brimming with kindergarten, primary, intermediate, and high school laboratory and normal school students. Relief was needed, and Fairchild saw an opportunity in the post–World War II building boom to construct a facility that would benefit both students and educators.

Work began on the new lab school in 1955, but planning for the structure started three years prior. The building was completed at roughly the same time as another campus structure, Schroeder Hall, so both held their dedication ceremonies on September 16, 1957. In this photograph, Pres. Robert Bone speaks at the Metcalf dedication ceremony.

The auditorium was not part of the original plan for Metcalf and was added in 1956. In 1960, the new auditorium was named for longtime first-grade teacher Annie Hayden. Speakers are seen in this 1960 photograph at the auditorium's dedication ceremony.

The new building allowed for much-needed breathing room in the laboratory schools. The elementary and primary grades moved to the new building, while the high school students remained in the old building. The original name was transferred so that the new building would be known as the Thomas Metcalf School while the older building would become University High School.

For the first 100 years, students at the university did not have a center or student-oriented activities spot to call their own. Several attempts were tried, most notably in the 1890s under fourth president John Cook. In 1945, a small snack area was opened in the basement of Fell Hall. The snack area became so popular that by 1953 a small dining area was opened.

The dining area, called The Cage, offered students a place to sit, talk, study, and grab a quick snack. Located on the first floor of Fell, The Cage had dining tables as well as a counter where students could sit and eat.

The push for a student center was again made during Fairchild's presidency. Similar to how the new student dormitories in Central Campus were funded, bonds were acquired and the campus was responsible for raising the rest of the construction funds. In this undated photograph, diners eat in Fell Hall while raising money for the new student center.

The campus community needed to raise $150,000 to begin construction on the building, referred to as the Student Union. This 1955 photograph shows the campus's fundraising efforts and financial need: "We must have $12,000 more in cash before April 18 if we are to break ground for the building."

The money was eventually raised, and ground was broken for the new Student Union in 1955. Here, a student can be seen taking part in the official ground-breaking ceremony. The occasion also called for a choir and a piano while students looked on.

Concepts for the Student Union included one drawing that featured a series of large windows on the right side of the building, a rounded corner on the left, and a covered walkway. This design was ultimately changed to include the iconic pillars that cover the smaller set of large windows on the Quad-facing side of the building.

The Student Union opened in September 1956. Now a major part of the university's growing Quad, the Student Union played a central role in student activities and social gatherings. To recognize the commitment the entire university had in raising the funds necessary to complete the building, the Student Union was renamed the University Union in 1960.

Once the Student Union was complete, the popular student snack spot, The Cage, made the move to the new building. Now officially part of the Student Union, The Cage had room for additional tables and kitchen equipment to offer larger meals.

Three

MODERNIZING CAMPUS

The arrival of Robert Bone as the university's ninth president in 1956 marked the start of the second century of education at the university. Predictions for student enrollment in the post–World War II era were high as veterans took advantage of the GI Bill. There was already a need for additional classroom space and housing, but with the increasing number of students each year, it became a pressing necessity.

During his presidency, Bone was able to procure funds to construct many of the residence halls that served the campus through the end of the 20th century. Atkin-Colby Halls and Hamilton-Whitten Halls, collectively known as South Campus, served thousands of students for over 50 years and provided quick access to the evolving Quad. Haynie, Wilkins, and Wright Halls, known as Tri-Towers, still serve current students, as do Manchester and Hewett Halls, known as East Campus. Perhaps his greatest achievement in his 11 years as the university's president was the construction of the ambitious 28-story Watterson Towers. In all of these residence halls, students made lifelong friendships, and many found their spouses. Bone's contribution to the university was more than just providing housing to a crowded campus—he continues to shape the lives of past, present, and future Redbirds.

Though his priority was housing, Bone was able to expand classroom space on campus with the addition of Stevenson Hall and DeGarmo Hall and the construction of a new building for University High School. Bone also moved sporting events out of the muddy South Campus fields to brand-new facilities, thus setting the footprint for athletics in West Campus and their expansion in the years to come.

Bone's presidency also brought a name change to the campus. The university dropped "Normal" from its name and, on January 1, 1964, became Illinois State University at Normal. Three years later, "at Normal" was dropped, and the university became known as it is today. Though growth on campus slowed after his presidency, the Robert Bone era forever changed the shape of Illinois State University (ISU).

After the resignation of Raymond Fairchild in 1955, the university began searching for its next president. With the construction of Hovey Hall, Milner Library, the University Union, and new residence halls, Fairchild's presidency created the footprint of ISNU's modern campus. However, it was during the presidency of Robert Gehlmann Bone (1906–1991) that many of the buildings on campus today were planned and constructed. Along with the modernization to a liberal arts institution and a name change, Bone either constructed or renovated more than a dozen campus buildings.

Schroeder Hall, one of the last buildings approved during Fairchild's presidency, was constructed to help alleviate the crowded classrooms on campus. Several classroom buildings were aging and in desperate need of repair. Old Main was closed for several months in 1946 due to structural failures, which only exacerbated the need for additional classroom space. Schroeder Hall was named for Herman Schroeder, longtime dean and two-time acting president for the university.

In 1964, an annex was added to Schroeder Hall to increase its classroom space. In this photograph, a time capsule is shown being placed in the cornerstone of the addition. The cornerstone and time capsule were removed in 2005 during a renovation at the annex.

The new Metcalf Elementary School building and Schroeder Hall were dedicated together on September 16, 1957. In line with then popular architectural trends, Schroeder Hall looked different than the rest of the buildings on the Quad. A plain, four-story, rectangular structure with windows wrapping almost the entire building, Schroeder Hall did not start to resemble the rest of campus until the 2005 annex and renovations.

The second iteration of Cardinal Court opened to student families in 1959. Located north of what is now Duffy Bass Field on Gregory Street, the new complex was a far cry from the temporary barracks. The complex had one- and two-bedroom apartments and was still primarily used by married students. An additional 96 apartments were built in 1964.

The barracks at the original Cardinal Court were bulldozed in 1962 to make way for the West Campus expansion. Room and board at the new Cardinal Court started at $53.40 a month for a one-bedroom apartment and $63 a week for a two-bedroom apartment. This iteration of Cardinal Court lasted until 2010, when the buildings were torn down and all-new buildings were constructed on the same spot.

A new building for the arts was planned during Fairchild's final years but was finished during Bone's presidency. The new, two-building facility would house the music, art, and the speech department (later called the theater department). Administration felt that the cornerstone from the university's first building should be saved and used as the new cornerstone for the complex, since it was being constructed during the university's centennial year. However, because of the late delivery of steel for the new building, construction did not start until 1958. The cornerstone contains contents from the time capsule placed in the cornerstone of Old Main in 1857.

The name "Centennial" was proposed by teachers college board member Clarence Ropp. The two buildings would later be known as Centennial East and Centennial West. Three performance spaces are named for longtime ISNU faculty: the Westhoff Theatre for Frank Westhoff, who was in charge of the music program at the university from 1901 to 1934; the Allen Theatre for Mabel Clare Allen, who was a theater faculty member from 1929 to 1967; and the Kemp Recital Hall for Benny Kemp, who was a piano instructor from 1963 to 1978.

Though the construction of Dunn, Barton, and Walker Halls helped alleviate some of the need for student housing, it did not solve it. The student population on campus was rapidly increasing, and in-town boarding facilities were becoming scarce. Incoming students were put on waitlists for beds. By 1959, construction on one of two new 10-story residence halls started.

The project to build the new residence halls was ambitious. The first of several construction projects during Bone's tenure, the residence halls were built where another beloved dormitory once stood, Smith Hall. The old home had to be razed and another building on the property relocated. Once construction began, the work moved fast. In this 1959 photograph, several community members, including Bone (far right), pose next to the Hamilton-Whitten Hall cornerstone. A time capsule was also placed in that cornerstone.

Hamilton Hall and Whitten Hall were dedicated on November 5, 1960, in conjunction with a university-sponsored "Dad's Day." The building had 810 beds and included an attached dining center that would serve both the Hamilton-Whitten building and the new residence hall that would be constructed on the north side of the lot. The east wing was named for Alma Hamilton, English teacher for ISNU and University High School from 1915 to 1943. The west wing was named for Jennie Whitten, foreign language professor and department chair from 1919 to 1959.

Though two residence halls, the building was often referred to as Hamilton-Whitten or simply "Ham-Whitt." The residents of Hamilton-Whitten were always active, participating in resident hall clubs and activities. In this 1970 photograph, a group of Hamilton-Whitten residents hang holiday decorations for a contest. Their theme was "Christmas Dreamland."

Atkin Hall and Colby Hall were the other half of the new South Campus residence hall complex. Just like its sister, Atkin-Colby had 810 beds and was attached to the other side of a joint dining center. The east wing was named for Edith Atkin, mathematics professor from 1909 to 1944. The west wing was named for June Rose Colby, professor of literature from 1892 to 1933. Colby was the third female professor hired at the university and one of the first women to graduate from the University of Michigan with a doctorate.

Once the foundation and basic structure of Atkin-Colby was constructed, the university held a cornerstone-laying ceremony. Similar to the time capsule installation for Hamilton-Whitten, a box containing information about the residents of South Campus and the university was placed into the cornerstone of Atkin-Colby. The ceremony placing the time capsule can be seen in this 1961 photograph.

Among the items found in the Atkin-Colby time capsule during the complex's 2016 demolition was this unidentified photograph dated November 1960. The image shows a float featuring an elephant with the university's Redbird mascot riding on top. The float declares " 'EARS' TO A FLYING VICTORY" and is parked in front of Hamilton-Whitten.

The dining center that served both Hamilton-Whitten and Atkin-Colby was constructed at the same time as Hamilton-Whitten. The facility served over 1,600 students daily and for many was the hub of their social activity on campus. The dining center even served as the site for dances held by both residence hall complexes. Known as the Feeney Dining Center, the facility was named for Mae Warren Feeney, who served as a dean and professor from 1936 to 1943.

This photograph from 1962 shows the layout of a room in Atkin-Colby and how many students typically decorated and socialized in their residence hall rooms. The photograph, taken by University photographer Nelson Smith, was typically used as a promotional image to show potential and incoming students the rooms available to them.

Parents were often involved in helping their children move into their new residence hall rooms. For many students, this was their first time away from home. In this 1964 photograph, a family helps their university student move into her room in Atkin Hall.

A group of residents watch an afternoon television program in a common room of Atkin-Colby in this 1962 photograph. Both residence halls offered residents various ways to interact in their halls, including interest groups, floor community groups and events, and common areas where residents could socialize.

South Campus served as a major residence complex for over 50 years, housing over 80,000 students. Due to the expense of needed renovations, the university decided to close South Campus in 2012. The buildings were demolished in 2016, and plans for future university buildings on the lot are currently being developed.

Located on the same site where the first University Farm once stood, Hancock Stadium makes up what is dubbed West Campus. On September 21, 1963, the inaugural football game was held. Over 7,500 were in attendance, the largest crowd for an ISNU athletic event at the time. The Redbirds won, beating Millikin 12-7. The stadium was named for Howard Hancock, longtime athletic director (1931–1963) and football coach (1931–1945).

The athletics complex in West Campus was originally made up of Horton Field House and Hancock Football Field. Attached to the fieldhouse was a press box that overlooked the bleachers and football field. In 2013, an east-side stadium addition was opened that included a new press box, bleachers, and event facilities.

Often referred to as the "P.E. Plant" during its construction, the new West Campus fieldhouse is home to a 75-by-75-foot pool, a six-lane track, a basketball court, and bleachers that can hold up to 8,000 spectators. For many alumni, Horton Field House was their home for Redbird athletics.

Horton Field House opened the week of September 16, 1963. Its dedication was held the same day as Hancock Football Field, September 28, 1963. The first graduation was held August 9 of that year, and on October 6, the first entertainment act, Peter, Paul, and Mary, performed. As reported by the *Pantagraph* on October 7, 1963, band member Paul Stookey "dedicated" the building, saying, "I take this opportunity to dedicate this hall for ISU for the years to come."

The fieldhouse was named for Clifford E. "Pop" Horton, who was best known as the founder of the Gamma Phi honorary gymnastics fraternity (Gamma Phi Circus) and the man who coined the university's current nickname, the "Redbirds."

Horton Field House served as the home for many university-sponsored athletics as well as classes for the School of Kinesiology and Recreation. But for many alumni, Horton is remembered as the anchor for university basketball and was the home for famed coach Will Robinson and ISNU basketball star Doug Collins.

Just as work was being finished on South Campus, plans were being made for another set of residence halls in the new West Campus. A set of three residence halls, all with a 420-bed capacity, were constructed directly west of the new football field and fieldhouse. After their completion, the West Campus residence complex became known as Tri-Towers.

As with the South Campus complex, the three new residence halls in West Campus had a dedicated dining facility. Linkins Dining Center was named for Ralph H. Linkins, professor of biological sciences and dean of men. On October 4, 1964, a cornerstone-laying ceremony was held and a time capsule was placed into Linkins Dining Center. Pictured here are Ralph H. Linkins (left) and Pres. Robert Bone (right).

Much like its South Campus sister facility, Linkins Dining Center was more than a food service facility. For many Tri-Towers residents, most daily social interaction happened in Linkins. In this 1968 photograph, food service workers serve the residents of Wright Hall Thanksgiving dinner.

Wilkins Hall, named for the first McLean County school superintendent and teacher's college board member, Daniel Wilkins, was the first of the three residences completed. In this 1964 photograph, a tour group looks out from the top of the recently completed residence hall at the other two halls still under construction.

Wright Hall was one of two men's residence halls (Wilkins was the first) in the Tri-Towers complex. The hall was named for Simeon Wright, namesake of the Wrightonian Literary Society and a professor known for giving away all his money to help the poorest of students on campus. After his death, the society placed a tombstone at his gravesite. In this 1965 photograph, residents wait for the phone in the hall's phone booth to be repaired.

Haynie Hall was the female residence hall in the Tri-Towers complex. The hall was named for Martha Haynie, the university's first female professor in 1876. In this 1967 promotional photograph, residents show how they have settled into their room. Wright and Haynie Halls were completed in 1966.

In an effort to keep up with the increasing student population, another set of residence towers was constructed, this time on the east side of campus. Plans to construct the new towers began in 1965 and were referred to as the "East Residence Group." To the west of the towers was the building that held Normal High School, also known as Central School. The university purchased the building in 1966 and used it as classroom space until it was demolished in September 1974.

In this 1965 photograph, two workers paint around the windows outside of Manchester Hall. The hall was named for Orson Leroy Manchester, dean of the normal university from 1911 to 1928. When the hall opened, it housed 800 men.

The other tower on the East Campus complex was named for third university president Edwin C. Hewett. Though he was unsuccessful in obtaining funding to construct much-needed classroom space and dormitory rooms on campus, it was fitting to name a residence hall in his honor. When the hall opened, it housed 792 women.

As with the South and West Campus residence halls, the East Campus residence complex had its own dedicated food service facility. Opened at the same time as Hewett Hall and Manchester Hall, the Vrooman Dining Center served breakfast, lunch, and dinner to hall residents. The dining hall was renovated in 2009 and converted into the Julia N. Visor Academic Center, a campus tutoring center.

Vrooman Dining Center was named for Carl Vrooman (1874–1966), a local resident and university supporter who served as the assistant secretary of agriculture in Woodrow Wilson's administration. During his tenure as assistant secretary of agriculture, Vrooman created the War Garden program, promoting home gardening and canning. Carl's wife, Julia (1876–1981), was also active, serving with the Young Women's Christian Association during World War I and helping American soldiers at the warfront.

Another of Robert Bone's facility projects was to construct a brand-new building for University High School. The school, then working out of present-day Moulton Hall, was in desperate need of space for both its students and faculty. The new laboratory high school was placed just north of the old University Farm on the corner of Main Street and Gregory Street. Plans were approved in 1963, and by that October, Bone, the citizens of Normal, and current and future University High School students took part in the ceremonial ground-breaking.

In this October 1963 photograph, students from University High School get shovels and help dig on the school's new site during the ceremonial ground-breaking. One of the students is seen wearing a "University High Pioneers" shirt.

The new high school was officially opened in April 1965. During the school's construction in 1964, a time capsule was placed in the cornerstone next to the front doors. During the school's 50th anniversary celebrations, the cornerstone was removed and the time capsule opened. Joan Wroan, 1945 University High School graduate, closed the capsule in 1964 and was on hand for the capsule's opening in 2016.

Opened in 1966, the Ruth Stroud Auditorium was an addition to the new high school. The auditorium was named for a longtime English teacher who had taught at University High School for 35 years and had recently retired.

Watterson Towers was among the last of the Robert Bone–era construction projects. From 1950 to 1967, six of the university's seven residence dormitories had been constructed at a cost of $25.5 million. The newest residence towers cost $14.2 million, over half of what all six halls cost to build. There were also plans for an additional 33-story tower, tentatively called Ropp Hall, north of the new University Union. Plans for that residence tower were scrapped.

When construction began on Watterson Towers in 1967, it was the largest single construction project ever for the Bloomington-Normal area. At 28 stories, the towers would be the tallest between Chicago and St. Louis and hold 2,200 residents. The north tower was completed and opened to students in 1968, while the south tower was completed in 1969.

As with all move-in days on a university campus, the experience can be daunting. For Watterson residents, scheduled move-in times for each house in the towers made the chore easier. Each tower has five houses named for the first 10 US secretaries of state: Van Buren, Clay, Adams, Monroe, and Smith in the South Tower and Madison, Marshall, Pickering, Randolph, and Jefferson in the North Tower.

Watterson also has a dining center in an attached building. Unlike its other residence hall counterparts, Watterson's dining hall was not named. However, like the other dining centers, Watterson's was often a hub of social activity. In 2010, the dining center was renovated and turned into the food-court-style Watterson Dining Commons.

In this 1969 photograph, residents in Watterson Towers show off their new room. As with the other residence halls on campus, men and women were housed in their own houses in the towers.

Another late construction project for Robert Bone was a new building for the university's humanities departments. Planning for a new building that would house faculty and students from mathematics, foreign languages, and English began in 1964. Several names for the new building were proposed and placed on a shortlist, including Adlai Stevenson II. The former governor of Illinois and United Nations ambassador had strong ties to the university; he was the grandson of university founder Jesse Fell and an alumnus of University High School.

Upon Stevenson's death on July 14, 1965, Bone and the university's governing board fast-tracked the naming of the building for him. They believed that his work in speechwriting and the United Nations made him the right choice in naming the new humanities building. Once the family gave their approval, and while Stevenson was lying in state at Bloomington's Unitarian church, the building's new name became official. Stevenson Hall opened in 1968 and has been heavily used since.

The new building for education and psychology was in the planning stages when Bone left the presidency in 1967. The building, already dubbed DeGarmo Hall by a university committee on future development and approved by the ISU Council and Board of Regents, would house the departments of education and psychology as well as clinical services. However, lawmakers in Illinois halted all new university construction, and it took several years for DeGarmo Hall to be built.

Named for Charles DeGarmo, an ISNU alumnus and former professor of modern languages, the five-story building featured mirrored windows and an open ground floor so that pedestrians could walk underneath the building from the Quad to University Street mostly unimpeded. Construction on the building finally started in 1971 and was completed by the summer of 1973.

By the mid-1960s, the university was planning for a new student union that could accommodate the social needs of the ever-increasing student body. A combination union and auditorium complex, the building was in the planning stages when Robert Bone left the presidency in 1967.

Original plans included an attached hotel, an ice-skating rink, and a bowling and billiards center in the union. The hotel and rink were cut, while a separate bowling and billiards building was constructed. Funds were finally authorized by the Board of Regents in August 1970, and construction began. In this photograph, school administrators and former president Robert Bone take part in the ceremonial ground-breaking for the new union complex.

The union would also be home to a 3,500-seat auditorium. Acts such as Victor Borge, Carlos Montoya, and the Chicago Symphony Orchestra were among the many performances held at the auditorium in its first season in 1973. The auditorium was renamed in 1982 at the university's 125th anniversary for the school's 10th president, Samuel Braden.

The new University Union was finished in August 1973, exactly three years after construction began. A small ribbon-cutting ceremony was held on September 30, 1973. However, the building was already in use; the Board of Regents held its monthly meeting 10 days prior in the Old Main Room.

Along with several meeting and conference spaces, the new University Union offered students six lounges where they could socialize or study. Many of the spaces featured artworks that were either permanent displays or rotating exhibits.

Though the University Union had several large lounges and spaces for students to relax and study, some preferred a quiet corner and small table, like these 1982 Redbirds. Along with various dining options, the union opened with 20 rooms, one ballroom, and six lounges.

Now in its third home, the Cage II was brought to the new University Union from the prior union building (now known as Old Union). The new Cage featured decorative "cages" reminiscent of the restaurant's namesake. It was estimated in 1979 by food service director Greg Black that 500,000 were served breakfast, lunch, and dinner in the Cage II each year. The Cage II was closed in the 1980s, and a bookstore (currently the Barnes and Noble bookstore) was installed in its place.

The bookstore was not always part of the University Union and, in 1982, the Board of Regents approved the establishment of both a bookstore and a McDonald's in the union. As a way to tie into the history of its former tenant, the bookstore installed features similar to the decorative "cages" that could be found in the Cage II.

The Crock 'n' Roll was another popular lunch spot in the University Union. Opened in January 1979, the Crock 'n' Roll took over what was once a vending machine area. Junior Carl Kichinko came up with the name for the new delicatessen in a naming contest. The table tops and wall art were designed by ISU art students. The location was eventually turned into the Cage II Coffee Shop, which closed in 2009 to make way for Einstein Bros. Bagels.

This 1985 information kiosk served as a quick stop for students looking for snacks and newspapers. The stand included informational brochures as well as gum, candy, and even a popcorn machine next to a drink cooler.

Elgio's Deli was another of several dining options made available to students in the Bone Student Center. The deli opened in January 1988 on the second floor near the bookstore and was a place for a quick sandwich on the go. Students could also sit on benches near the deli to eat and visit with friends.

Popular regional pizza chain Garcia's Pan Pizza also had a location in the Bone Student Center. Known for its "Pizza in a Pan" that was sold by the slice, the student center location was once one of five in the Bloomington-Normal area.

Four
A NEW NORMAL

Arguably one of the most popular presidents in the university's history, Robert Bone left a large and visible mark on the campus. For his successors, following his example would be difficult. Growing social movements such as the Civil Rights Movement and conflicts like the Vietnam War would consume the student body and become part of the daily discourse on campus. Later presidents found it difficult to secure funding for even the smallest projects and often would scale back or eliminate planned construction.

Projects that did make it to construction included the university's new library facility, Milner Library. The old Milner Library (now known as Williams Hall) was nearing capacity and was not equipped to handle the projected number of incoming students in the coming decades. With some funding and construction delays, the new Milner Library was finally built next to the new University Union (now known as Bone Student Center). Milner Library remains today, much as Old Main once was, the academic heart of the university. Along with Milner, other innovative campus buildings were constructed, including the new Science Laboratory Building and Center for the Performing Arts and a new home for the College of Business in the State Farm Hall of Business. And with its state-of-the-art roof and incredible seating, Redbird Arena was constructed as the new home for basketball and women's volleyball (although Reggie Redbird might suggest the university built the arena just for him).

Just like the planners who developed the first building on campus over 160 years ago, the university is once again planning for new, innovative, and state-of-the-art facilities to provide quality education to its students. ISU can tell its story through its many buildings that shape the campus. These structures each tell unique stories: some of leading educational developments, some of cutting-edge breakthroughs, and some simply the stories of lasting relationships and perseverance. Collectively, they all tell the most important story: the history of the Redbirds of Illinois State University.

After Robert Bone's retirement in 1967, Samuel Braden (1914–2003) was selected as ISU's 10th president. Though he had been with the university since 1937, Braden only served as president for three years. He faced enormous financial burdens and student social concerns that made his presidency difficult. Existing construction was largely scaled back, while buildings he planned never came to pass. In recognition of his commitment to students, the auditorium in the University Union was named in his honor in 1982 at the university's 125th anniversary celebration.

In the final months of Bone's presidency, the University Committee on Future Development recommended that a new library building be planned. Estimates for student enrollment in the next decade were near 30,000, and university administration saw the need for a larger library facility. Five months after Braden became the university's 10th president, planning for the new building began.

Construction started on July 21, 1972. It was originally priced at $11 million, but regents and administrators felt that the cost for the library was too high. Plans for the new library were updated and construction costs were lowered to $8 million. Construction finally began on the new library on July 21, 1972. However, the original contractor went bankrupt, delaying construction and the library's opening. A new contractor was located and had to fix issues by the previous contractor before work could begin.

The new Milner Library was finished in 1976 and built to accommodate up to 7,000 students. The new building could hold 800,000 volumes and featured spacious lounge areas that overlooked the Quad. The old Milner Library was renamed in 1981 for Arthur R. Williams (1857–1952), who was the first head of the Department of Business Education.

The library was able to open earlier than originally planned, having moved most of the old library's materials into the new building in two weeks. Library administration planned for the move to take a month and for periodic closures. The library never closed completely, staying open for several hours during the day and assisting students with research. The move from the old library to the new building began on June 14 and was completed in time for the official library opening on July 1, 1976.

When the new library was first opened, it was already using state-of-the-art technology. Then library director Joe Kraus enrolled the library in the Ohio Library College Center (later known as the Online Computer Library Center) to access computerized catalog records. Though the library still relied on paper catalog cards, users could use a dedicated terminal to access online catalog records.

Students in this 1990 photograph show university photographer Nelson Smith how to use and access online catalog records. The library stopped using paper card catalog records and began using only online catalog records in 1989.

A tent structure was installed in 2000 in an effort to stop leaks from occurring on the first floor of Milner Library. The permanent tents were designed not only to help control constant leaks but to match another building with a circus theme, Redbird Arena. Repairs to the entire plaza and upgrades to both Milner Library and Bone Student Center are slated to begin in 2017, at which time the tent structure will be permanently removed. (Photograph by the author.)

On April 3, 1984, the university announced plans for a new sporting and entertainment arena. The administration had looked at renovating Horton Field House but ultimately decided on new construction, citing the dramatic increase in student enrollment from the 1960s to the present. The new arena would be placed near Horton Field House not only to take advantage of the existing parking but also to keep all athletics in a central location.

Though a portion of construction funds would come from bond revenues and $825,000 raised by the community, students would need to approve a fee increase. In April 1984, the student body voted to raise fees by $34 to pay for the arena. With funding acquired, the arena could move forward. However, regents and administrators felt the project was too expensive, and plans were redesigned. Work finally began on May 8, 1986.

Before work could begin, Redbird Field had to be retired. The site for many baseball games, the field officially closed on May 4, 1986, to a rendition of "Taps." In 1988, Duffy Bass Field was opened west of University High School and named for the longtime university baseball coach.

The arena bowl was designed by CRS Sirrine, Inc., and Paul Kennon, while the Teflon-paneled roof was designed by engineer David Geiger of New York. The roof is made of 24 Teflon-coated fabric panels that are lined with insulation and cable supported. At the time of installation, the roof on Redbird Arena was the only one of its kind in the United States. When the arena hosts night events, the lights filter through the roof, giving it a soft glow.

Redbird Arena officially opened on January 11, 1989, when the ISU men's basketball team played Chicago State. The Redbirds won 71-70. At its opening, the new arena included 10,500 seats in the upper and lower bowls as well as floor seats. Horton Field House could only hold just over 7,500. Additionally, bleachers were installed for the band. The official dedication ceremony took place on April 6, 1989.

Redbird Arena has been home to many exciting games for ISU basketball and volleyball fans. Because of the arena's bowl design, even the highest seats in the upper bowl have clear and unobstructed views of the main court. In this photograph from March 6, 1990, fans in the upper bowl cheer on ISU as they beat Southern Illinois 81-78, winning the Missouri Valley Conference Championship and earning a spot in the NCAA Tournament.

Today, Redbird Arena serves as the home for men's and women's basketball as well as women's volleyball. Commencement ceremonies are also held in Redbird Arena. On February 3, 2007, the court was named for ISU basketball legend Doug Collins, who started at the university from 1971 to 1973.

Redbird Arena is not just the home to ISU basketball and women's volleyball. It is also the home of the mascot, Reggie Redbird. Though many redbirds in Reggie's family have taken on the role of Redbird mascot, Reggie himself was not officially named until 1981. Since then, Reggie has taken up residence in a cozy nest he has made above the scoreboard in Redbird Arena.

New construction on campus slowed almost to a halt after the opening of Redbird Arena. Financial constraints hindered campus administration from starting work on much-needed facilities. Thomas Wallace, the 14th president of the university, stepped down in 1995, and David Strand (1935–), pictured on the left was named interim president. Strand oversaw the completion of the Science Lab Building and brought the Mennonite College of Nursing to campus as its sixth academic college.

A new building for chemistry and biology had been in the planning stages since the 1960s. The building was not realized until the Illinois General Assembly approved the funds for the $29.2-million building on July 13, 1994. The new science building was to be located next to Julian Hall, named for former Board of Regents member Percy Lavon Julian. Ground-breaking for the building was held on October 17, 1994.

The new science building would hold state-of-the-art laboratories and classrooms, while Julian Hall would house offices for biology and chemistry faculty. A walkway was constructed between the two buildings, joining them together. Named the Science Laboratory Building, it was dedicated on September 9, 1997. In this photograph, chemistry and biology faculty, administrators, students, and community members gather for the dedication and to tour the building.

The Mennonite Sanitarium Training School was founded in 1919 as a training school for the nursing profession. Part of Mennonite Hospital, the school saw its first graduates earn nursing diplomas in 1922. The program changed in 1982 to the Mennonite College of Nursing and, in 1995, the college was given approval for the Master of Science in Nursing Program. In 1999, President Strand moved the college to ISU and made it the university's sixth academic college. This photograph shows the original Mennonite Hospital, which was demolished in 2015.

The Mennonite College of Nursing at ISU has since grown, expanding its academic offering to include two doctoral programs. In 2011, the Nursing Simulation Lab was opened for students of the college. The lab gives students real-life training in a controlled setting using patient simulators. (Courtesy of Lyndsie Schlink, university photographer, Illinois State University.)

The Kaufman Football Building was the first building on the university's campus to be named for a benefactor. Utilized by the ISU football team, the building was named for alumni Fred and Donna Kaufman, who donated $1.5 million to the university's Athletics Department. The building holds offices for the coaching staff as well as a locker room, training facility, equipment room, and meeting room for the entire team. The building opened for use in 2000 and is next to Hancock Stadium. (Courtesy of Lyndsie Schlink, university photographer, Illinois State University.)

Seeing the need for a new performing arts space, Strand proposed a $42-million building project that would include a new performing arts center, a third parking deck near South Campus, and improvements for campus dormitories. The project was to be financed by bonds paid with student fees, which needed to pass a student referendum before it could begin. The referendum was passed, and work on the Center for the Performing Arts started on February 16, 1999. (Courtesy of Lyndsie Schlink, university photographer, Illinois State University.)

The new performance space would ultimately feature an 800-seat concert hall, a 450-seat theater, a two-story lobby with a box office area, and an exhibition hallway. Faculty offices would remain in both Centennial East and Centennial West, and Westhoff Theatre was renovated in 2002. The Center for the Performing Arts opened on October 18, 2002, with a dedication ceremony, various performances in the concert hall, and an opening night performance of *The Tempest* on the main stage. (Photograph by the author.)

In this photograph from September 2003, patrons fill the main lobby of the Center for the Performing Arts as they wait for the doors to the house to open. (Courtesy of Pete Guither.)

The Center for the Performing Arts also serves as a multiuse space for the university. In this photograph from May 2016, an ROTC student is given her commission by her sister at the ISU Army ROTC commissioning ceremony. (Photograph by the author.)

In the final year of David Strand's presidency, locally based State Farm Insurance donated $9.5 million to the university for a new building to house the College of Business. At the time, the donation was the largest in the school's history. The building was to be located south of the Quad, where decades prior, many of the university's athletic events were held. The 118,000-square-foot building opened on January 15, 2005, and was officially named the State Farm Hall of Business in October 2010. (Photograph by the author.)

After serving as interim president in 2003, Clarence Alvin "Al" Bowman became ISU's 17th president on March 1, 2004. Bowman had been with the university since 1978. As president, he created a salary enhancement plan, bringing salaries at ISU up to the same pay level as other peer institutions. He was also involved in the development of some of the university's more recent campus building additions, including the Alumni Center, the Student Fitness Center, and the Hancock Stadium upgrades. (Courtesy of Lyndsie Schlink, university photographer, Illinois State University.)

In October 2006, a proposal for renovating an existing building on North Main Street near the Interstate 55 interchange was brought before the ISU Board of Trustees. The proposal called for the purchase of the former Eagle Country Market store and to renovate the space to become the new home for Alumni Relations, the ISU Foundation, and University Marketing. The location was considered ideal, as it was close to the interstate and alumni could stop at the center before they made the short drive to the university. (Courtesy of Lyndsie Schlink, university photographer, Illinois State University.)

Renovations began in August 2007 as the former store was divided by steel framing into offices and meeting rooms. The contractor for the job called in a helicopter to lift 17 air handling units, each about the size of a small car, to the roof of the building. (Courtesy of Lyndsie Schlink, university photographer, Illinois State University.)

Known simply as the Alumni Center, the space was opened in July 2008 and celebrated its first homecoming in the building later that year. The building currently houses eight different services that cater to alumni, annuitants, donors, and the local community. (Courtesy of Lyndsie Schlink, university photographer, Illinois State University.)

By the 1990s, the university saw an increase in demand for a student gymnasium. In response, the university converted a former ice rink on Beech Street into a dedicated student gym. The university also unsuccessfully sought funding in 2002 to construct a larger facility. However, in May 2002, the student government held a referendum showing that students were in favor of a fee increase to build a student recreational center. (Courtesy of Lyndsie Schlink, university photographer, Illinois State University.)

In May 2006, the Board of Trustees approved a design phase for the new student gym. The project was approved by the board the following year, and after demolition of the old Central Campus site, construction on the new complex began. It would include an indoor track, a swimming pool, 22,000 square feet of cardio and weight training, and a rock climbing wall, pictured here from the front lobby. (Courtesy of Lyndsie Schlink, university photographer, Illinois State University.)

The project also included the renovation of McCormick Hall, where the School of Kinesiology and Recreation would reside. The construction of the new recreation facility and the renovation of McCormick Hall was the single largest construction project to that point in the university's history. Project planners hoped to have the building ready for its grand opening by August 2010, the centennial anniversary of the university's physical education program. The 170,000-square-foot Student Recreation Center officially opened on January 10, 2011. (Courtesy of Lyndsie Schlink, university photographer, Illinois State University.)

The dormitories of Dunn, Barton, and Walker Halls were torn down in order to make room for the new Student Recreation Center. As a way to keep the university's past in the present, site planners placed several of the entry columns from Walker Hall along the sidewalk on the side of the Student Recreation Center that faces Main Street. The columns would serve as benches but also remind former and current students of the Redbird alumni who once called Central Campus home. (Photograph by the author.)

Cardinal Court, which for years had been the housing for married and graduate students, was in need of major renovations. This was the second iteration of the complex, constructed in 1959. As part of a larger multiyear student housing renovation project across campus, the ISU Board of Trustees decided to embark on the university's first public-private housing complex. Demolition of the old Cardinal Court began in the spring of 2011, and ground-breaking for the new apartment complex was held in May 2011. (Courtesy of Lyndsie Schlink, university photographer, Illinois State University.)

Brick, asphalt, and concrete from the old Cardinal Court was recycled and used as the base layer for the new complex. When finished, the 228-unit complex could house over 800 students and would feature amenities such as a community center, outdoor volleyball and basketball courts, a theater room, and a café operated by campus dining. The complex was dedicated on August 9, 2012, and student residents moved into their new units that fall. (Courtesy of Lyndsie Schlink, university photographer, Illinois State University.)

One of Al Bowman's last projects before his retirement in 2013 was the renovation of Hancock Stadium. Plans to renovate the stadium had been discussed for years but were sidelined in favor of other campus facility projects. While the aging facility was in desperate need of new seating, many, including Bowman, saw an updated stadium as a valuable recruiting tool for the campus. At his state of the university address on September 27, 2011, Bowman announced a $20-million plan to renovate the stadium. (Courtesy of Lyndsie Schlink, university photographer, Illinois State University.)

The ISU Board of Trustees officially approved the stadium renovation project in February 2012, and work began that fall. The plan called for the east-side seating to be replaced and backed by a two-story structure that would include luxury suites, an outdoor terrace, a club level, and an updated media and production facility. The new stadium was dedicated on September 18, 2013, and the first game was played on September 21, the 50th anniversary of the first game played in Hancock Stadium. (Courtesy of Lyndsie Schlink, university photographer, Illinois State University.)

BIBLIOGRAPHY

Daily Pantagraph (Bloomington, IL), 1891–1985.

Eleanor Weir Welch University Librarian (Dean) Papers. Dr. JoAnn Rayfield Archives, Illinois State University, Normal, Illinois.

Freed, John B. *Educating Illinois: Illinois State University, 1857–2007*. Norfolk: The Donning Company Publishers, 2009.

Harper, C.A. "Old Main." *Illinois State Normal University Bulletin* vol. XLIV (September 1946).

Illinois State University. *Annual Catalog* (1860–). Dr. JoAnn Rayfield Archives, Illinois State University.

Illinois State University. *The Index: Class Annual* (1892–1972). Dr. JoAnn Rayfield Archives, Illinois State University.

Illinois State University Athletics Collection. Dr. JoAnn Rayfield Archives, Illinois State University, Normal, Illinois.

Illinois State University Homecoming Collection. Dr. JoAnn Rayfield Archives, Illinois State University, Normal, Illinois.

Illinois State University Photographic Services Collection. Dr. JoAnn Rayfield Archives, Illinois State University, Normal, Illinois.

Pantagraph (Bloomington, IL), 1985–.

Perry, Charles William. "Angeline Vernon Milner." *The Alumni Quarterly of the ISNU* (May 1924): 2–10.

Raymond Fairchild Presidential Papers. Dr. JoAnn Rayfield Archives, Illinois State University, Normal, Illinois.

Records of Illinois State University Governance. Dr. JoAnn Rayfield Archives, Illinois State University, Normal, Illinois.

Records of the Mennonite College of Nursing. Dr. JoAnn Rayfield Archives, Illinois State University, Normal, Illinois.

Records of Milner Library. Dr. JoAnn Rayfield Archives, Illinois State University, Normal, Illinois.

Vidette (Illinois State University, Normal, IL), 1888–.

World War I Illinois State Normal University Military and Community Service Records. Dr. JoAnn Rayfield Archives, Illinois State University, Normal, Illinois.

World War II Illinois State Normal University Campus Activities Collection. Dr. JoAnn Rayfield Archives, Illinois State University, Normal, Illinois.

INDEX

Adcock, Ada, 36
Allen Theatre, 75
Alumni Center, 120, 121
Atkin-Colby (South Campus), 43, 71, 78–81
Babbitt, Ellen, 37
Barton Hall (Central Campus), 59, 60
Bone, Robert Gehlmann, 64, 71, 72
Bone Student Center (University Union), 98–104
Bowman, Clarence Alvin "Al," 119
Braden Auditorium, 99
Braden, Samuel, 106
Brown, Harry Alvin, 40
Cage, The, 66, 70, 101
Capen Auditorium, 27
Cardinal Court, 54, 55, 74, 124
Centennial Building, 75
Center for the Performing Arts, 105, 117, 118
Cook Hall, 19
Cook, John W., 22
DeGarmo, Charles, 21
DeGarmo Hall, 71, 97
Dunn Hall (Central Campus), 58–60
Edwards Hall, 25–27
Edwards, Richard, 18
Fairchild, Raymond, 25, 43
Feeney Dining Center (South Campus), 79
Fell Hall, 31–33, 51, 66, 67
Fell, Jesse W., 10, 15
Felmley, David, 25, 26, 39
Felmley Hall of Science, 38, 39
Hamilton-Whitten (South Campus), 43, 71, 76, 77, 79
Hancock Stadium, 82, 125
Hayden Auditorium, 65
Haynie Hall (Tri-Towers), 71, 85, 87
Hewett, Edwin, 18
Hewett Hall (East Campus), 71, 88, 89
Horton Field House, 82–84
Hovey, Charles Edward, 12–15
Hovey Hall (Administration Building), 56, 57
Illinois Soldiers and Sailors Children's School, 17
Index, 35, 37, 50
Kaufman Football Building, 116
Kemp Recital Hall, 75
Lincoln, Abraham, 10, 15

Linkins Dining Center (Tri-Towers), 85, 86
Lutz, David, 34
Manchester Hall (East Campus), 71, 88
McCormick Gym, 40, 41
Mennonite College of Nursing, 115, 116
Metcalf Training School, 64, 65, 73
Milner, Angeline Vernon, 20, 34, 36, 37, 46
Milner Library, 47–49, 105–109
Moulton Hall, 25, 30
North Hall, 17
Old Main (Administration Building), 9–17, 23, 75
Old Student Union, 68, 69
Rambo House (Home Management House), 44, 45
Redbird Arena, 105, 110–113
Reggie Redbird, 105, 113
Schroeder Hall, 72, 73
Science Laboratory Building, 105, 114, 115
Smith Hall, 42, 43
State Farm Hall of Business, 105, 119
Stevenson Hall, 71, 96
Strand, David, 114
Student Fitness Center, 122, 123
Tompkins, Arnold, 22
University Farm, 28, 29
University High School, 71, 91, 92
V-12 Training Program, 25, 51–53
Vidette, 23
Vrooman, Carl and Julia, 90
Vrooman Dining Center, 90
Walker Hall (Central Campus), 61, 62, 123
Watterson Towers, 71, 93–95
Welch, Eleanor Weir, 46
Westhoff Theatre, 75
Wilkins Hall (Tri-Towers), 71, 85, 86
Wright Hall (Tri-Towers), 71, 85, 87

DISCOVER THOUSANDS OF LOCAL HISTORY BOOKS FEATURING MILLIONS OF VINTAGE IMAGES

Arcadia Publishing, the leading local history publisher in the United States, is committed to making history accessible and meaningful through publishing books that celebrate and preserve the heritage of America's people and places.

Find more books like this at
www.arcadiapublishing.com

Search for your hometown history, your old stomping grounds, and even your favorite sports team.

Consistent with our mission to preserve history on a local level, this book was printed in South Carolina on American-made paper and manufactured entirely in the United States. Products carrying the accredited Forest Stewardship Council (FSC) label are printed on 100 percent FSC-certified paper.

MADE IN THE USA